THE ENGLISH DREAMERS

THE ENGLISH DREAMERS

Edited by David Larkin

Introduction by Rowland Elzea

Pan Books Ltd
London and Sydney

We are most grateful to the galleries, private collectors
and museums who have kindly allowed the use of material
in their copyright.

THE ENGLISH DREAMERS

Copyright © 1975 by Bantam Books, Inc.

All rights reserved under International and Pan-American conventions

This edition published 1975 by Pan Books Limited
18-21 Cavaye Place, London SW10 9PG

This book may not be reproduced in whole or in part, by
mimeograph or by any other means, without permission in writing.
For information, address: Peacock Press, Bearsville, New York 12409, U.S.A.

ISBN 0 330 24502 3

PRINTED IN ITALY BY MONDADORI, VERONA

Irrationality and super-clarity are the two elements that all dreams seem to have in common. The life-like clarity causes one to overlook the rational flaws of a dream and to be swept up on its wings. Like a great work of fiction, a dream is totally convincing. Only when the grip of the irrational thrusts one into a vortex whose end is certain death does the dreamer rebel and rip away the cobwebs which bind him. The English Victorian painters whose works are shown in this book have dealt with this delicate mental balance between reality and illusion in a way which the later dream painters, the Surrealists, could not approach because of the very fact that psychoanalysts like Freud and Jung had made attempts to explain and thus rationalize the nature of a dream. Dali's "hand painted photographs of concreate irrationality," as he calls them in *The Secret Life of Salvador Dali*, were doomed to failure, from their inception as dream images at least, because of the artist's consciousness of what he was about.

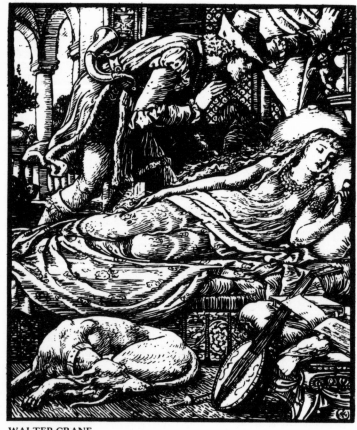

WALTER CRANE

The dreamer feels as disengaged as a person watching a film. He is a spectator to his own mind. In looking at the pictures in this book, one has the feeling that one is seeing a "still" from the cinematic dream-world of a man living in late Victorian times. The reference to a dramatic production is not accidental. The feeling is that the still is taken from the few seconds of film just preceeding the cataclysmic denouement of the episode—the vortex from which, once entered, there is no return. Morgan le Fay's spell, of which she herself dreads the power, is about to erupt; the unheard of bond is about to be made between the Woodman's Daughter and the squire's son; Danae's dubious look before setting foot on the fateful path to the brazen tower, or the final word of the spell which Numue is about to read to close Merlin's baleful eyes—all are among those decisive moments which the more gifted dreamers were

able to portray. Other artists like Brown, Brett or Scott, whose sense of the dramatic moment is not as finely honed, instead leave us with the feeling of merely having seen a still from a

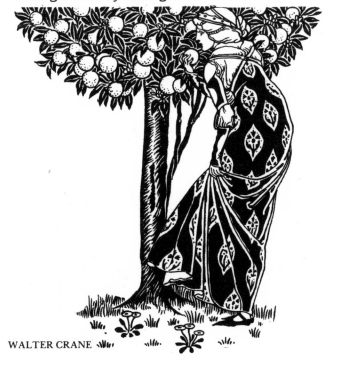

WALTER CRANE

"spectacular" historical film. Indeed one feels certain that in some of these paintings, particularly Brown's, lies the inspiration for some of the great scenes by cinema directors like Eisenstein or Griffith.

These paintings are literary paintings as opposed to those conceived as "art for art's sake." Just how literary some of them are can be seen by the texts which some artists, Hunt particularly, wrote to explain the symbolism in their paintings. Hunt wrote an explanation of over 700 words for his "Lady of Shalott." Still, that is some 300 words short of the value of a picture!

Nearly every one is an illustration of a moment in some literary work whether poem, novel or play. Hunt's *Hireling Shepherd*, for instance, was taken from *King Lear*. Many of the artists

were also writers or were closely associated with literary men and women. In the same close social circle as the painters and writers were the theater people. Actors and actresses appeared in paintings both as subjects of portraits and as models in narrative paintings. In turn, stage sets and costumes were sometimes designed by painters. Burne-Jones' sets for *King Arthur* by Comyns Carr were notable among them. Novels were written with artists heroes, the real life models of which were often only thinly disguised. The theater, however, seems to have been the most direct point of contact between our artist dreamers and the rest of the art world. Both were literary, both were visual, both were concerned with dramatic impact. In her memoirs, *The Story of My Life*, the Actress, Ellen Terry, the wife of the painter G. F. Watts for a short time, describes the production of Tennyson's play *The Cup*, first produced in 1884, in a way which makes its

pictorial concept and rhythms apparent.

"A great deal of the effect (in the scene in the Temple of Artemis) was due to the lighting. The gigantic figure of the many-breasted loomed through a blue mist, while the foreground of the picture was in yellow light. The thrilling effect always to be gained on the

WILLIAM MORRIS

stage by the simple expedient of a great number of people doing the same thing in the same way at the same moment, was seen in 'The Cup', when the stage was covered with a crowd of women who raised their arms above their heads with a large, rhythmic, sweeping movement and then bowed to the goddess with the regularity of a regiment saluting . . .

"Quite as wonderful as the Temple Scene was the setting of the first act, which represented the rocky side of a mountain with a glimpse of a fertile table-land and a pergola with vines growing over it at the tip. The acting in this scene all took place on different levels. The hunt swept past on one level; the entrance to the temple was on another. A goatherd played upon a pipe . . .

"Henry Irving was not able to look like the full-lipped, full-blooded Romans such as we see

WILLIAM MORRIS

in long lines in marble at the British Museum, so he conceived his own type of the blend of Roman intellect and sensuality with barbarian cruelty and lust."

Both painting and the theater could contain a moment in which reality was suspended and one could approach as nearly as possible the tension of the dreaming state while in the waking one. This could extend through Masques and pageants to the operatic productions of Wagner. The point upon which they all agreed was that the artificial arena of time and space should be as real as possible so that disbelief could the more readily be suspended. The rejection, by the Pre-Raphaelites and the later dream-painters, of atmospheric perspective, as was so effectively used by Turner and Constable and the other English landscape painters, was not only to attain the super-clarity of the dream, but was also probably influenced by stage sets in which, even though an illusion of space was given, the viewer was aware that the physical depth of the stage was very limited and that, in fact, the

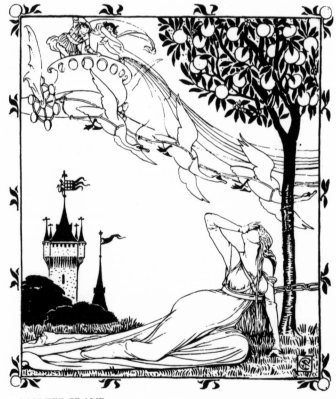

WALTER CRANE

drops upon which vast vistas were painted or the back-lit gauzes behind which Woglindes on wheeled stilts were pushed by perspiring stagehands were very close to one.

But the time that was congenial to these dreamers was not to last into the 20th century. The climate that nurtured them was a very special one. The painterly winds were blowing from an easterly direction and the literary ones from the north. By the end of the century the English Theater was beginning to turn from Shakespearean pageantry and the estheticism of Wilde to the realism of Ibsen and Shaw, and painting was beginning to go in the direction pointed by the turn-of-the-century French painters—the painterly and granular surfaces of the Impressionists and the direct stimulation of emotion by color relationships that the Fauves and Expressionists were experimenting with.

These Continental currents were absorbed by English artists in their own way, and the influence of the English Dreamers on Continental Symbolism and the Secession school of craftsmen and through them, later, on the Nabis, Fauves and Cubists is not to be denied. However, the innocence and directness of vision which allowed Waterhouse, Strudwick and the others to depict their visions in the way they did was gone.

Rowland Elzea
CURATOR OF COLLECTIONS
DELAWARE ART MUSEUM

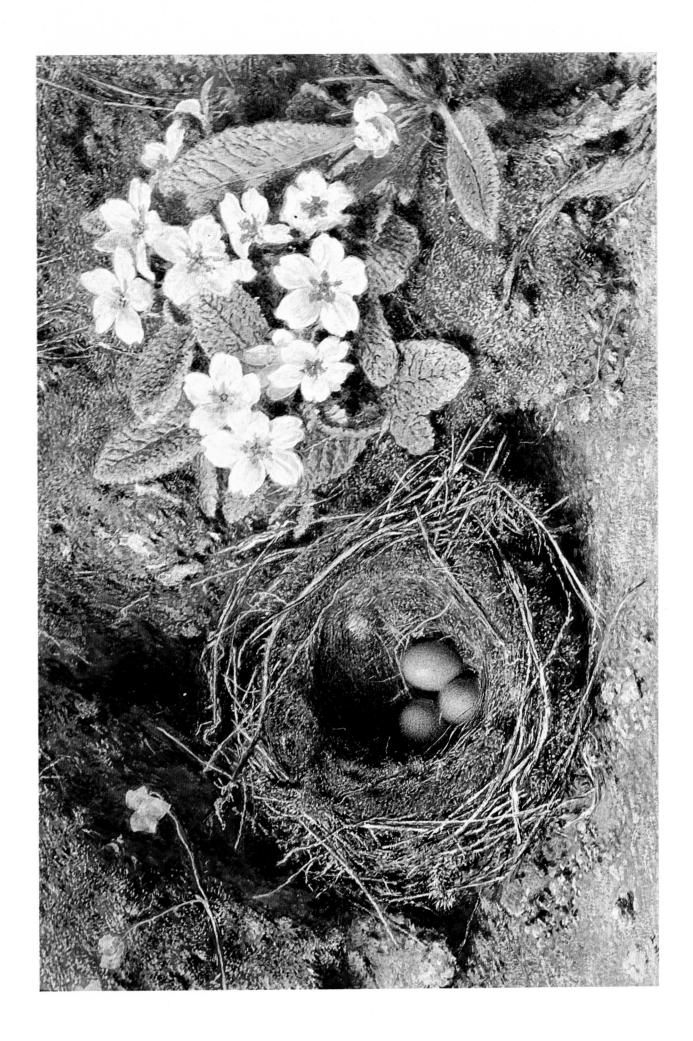

1) Primroses and Bird Nest

7¼ x 10¾″

WILLIAM HENRY HUNT

1790-1864

Tate Gallery, London

Photo—M. Slingsby

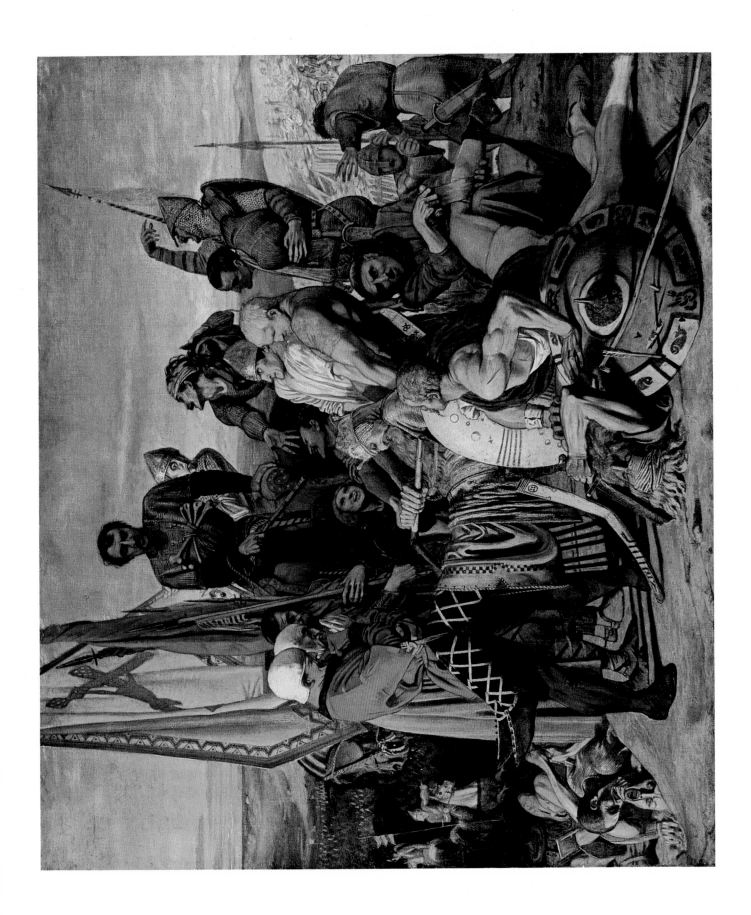

2) The Body of Harold brought before William the Conqueror
1844-61 41½ x 48¼"
FORD MADOX BROWN
1821-1893

Manchester Art Gallery

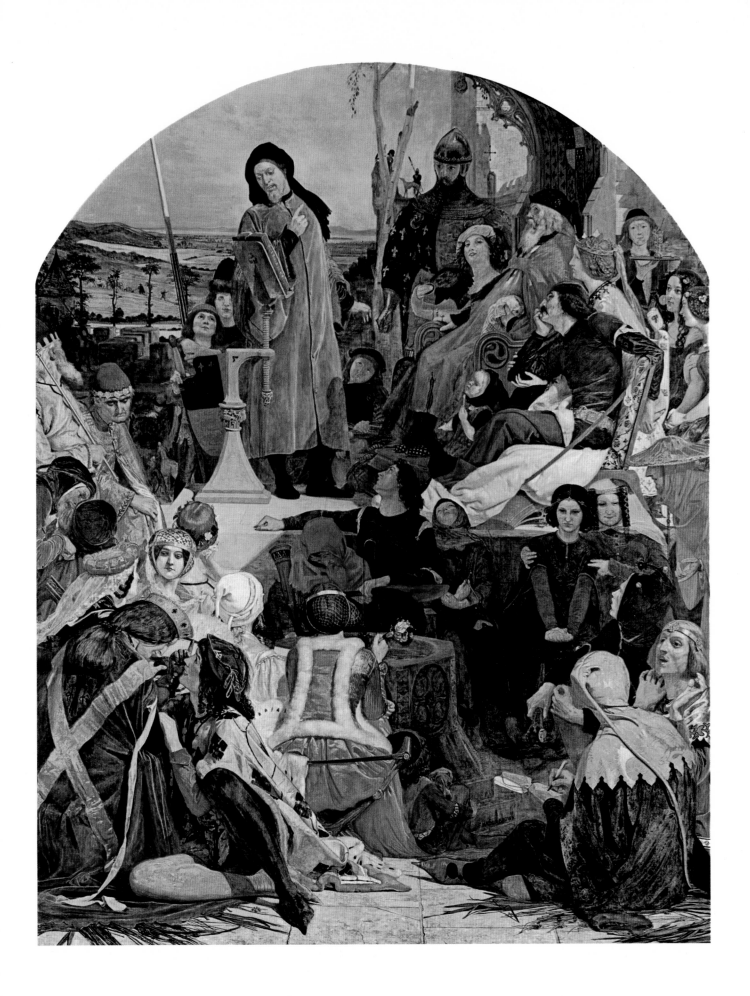

3) Chaucer at the Court of Edward III
1845-51 146½ x 116½"
FORD MADOX BROWN
1821-1893

Art Gallery of New South Wales, Sydney

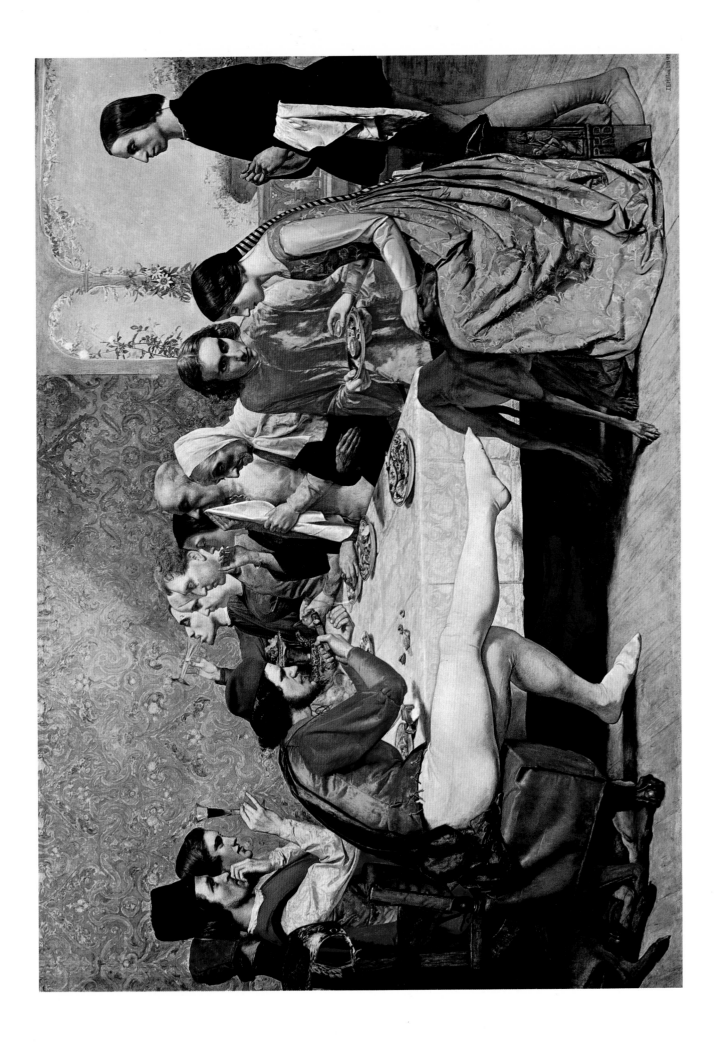

4) Isabella

1849 40½ x 56¼″

JOHN EVERETT MILLAIS

1829-1896

Walker Art Gallery, Liverpool

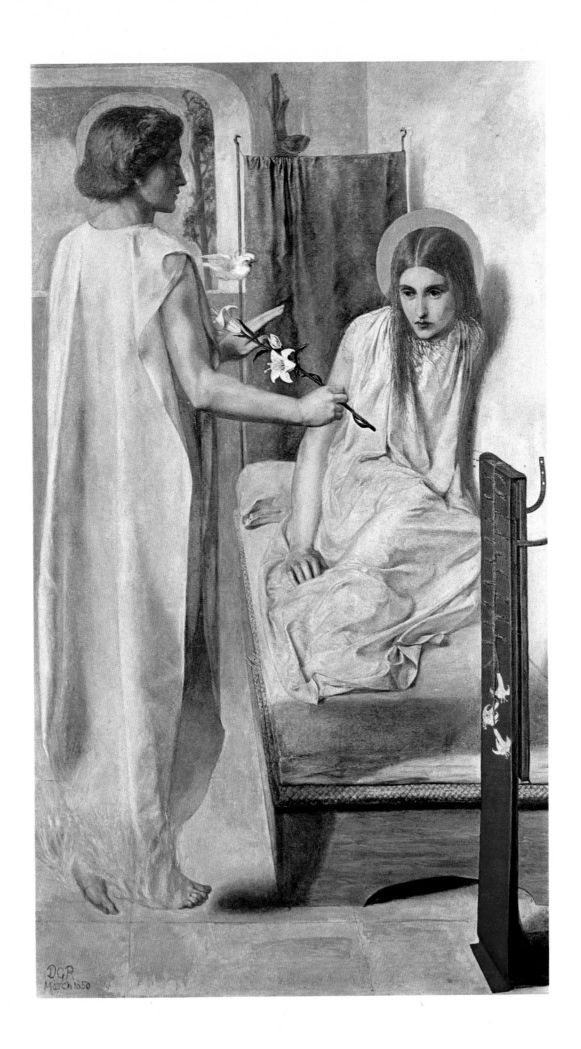

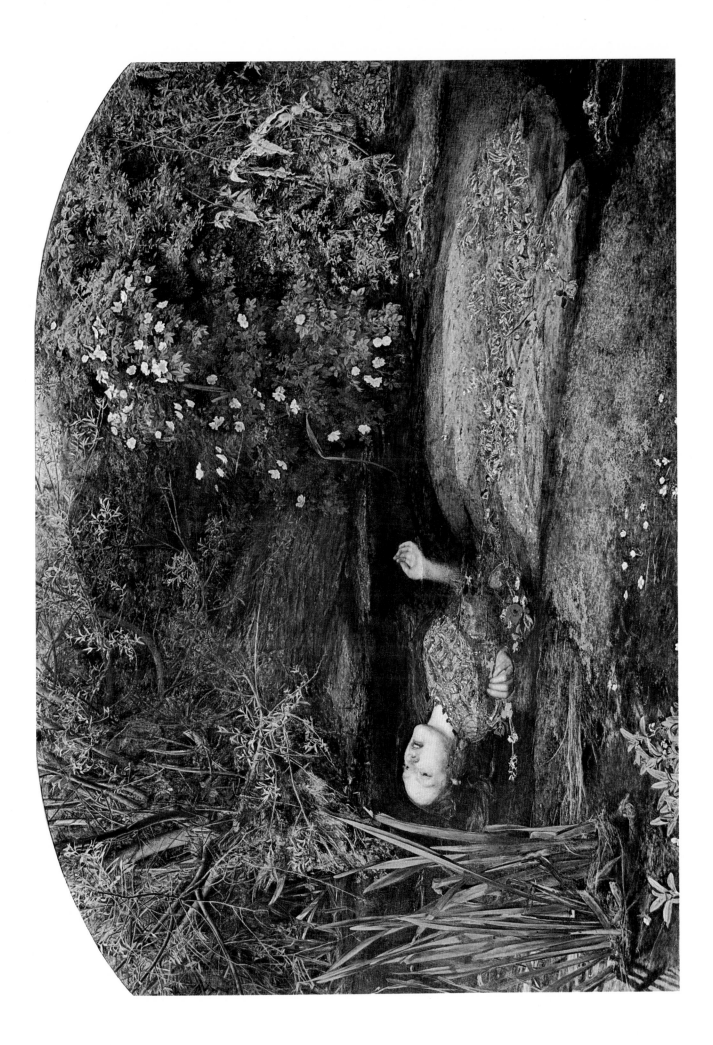

6) Ophelia
1851-52 30 x 44″
JOHN EVERETT MILLAIS
1829-1896
Tate Gallery, London

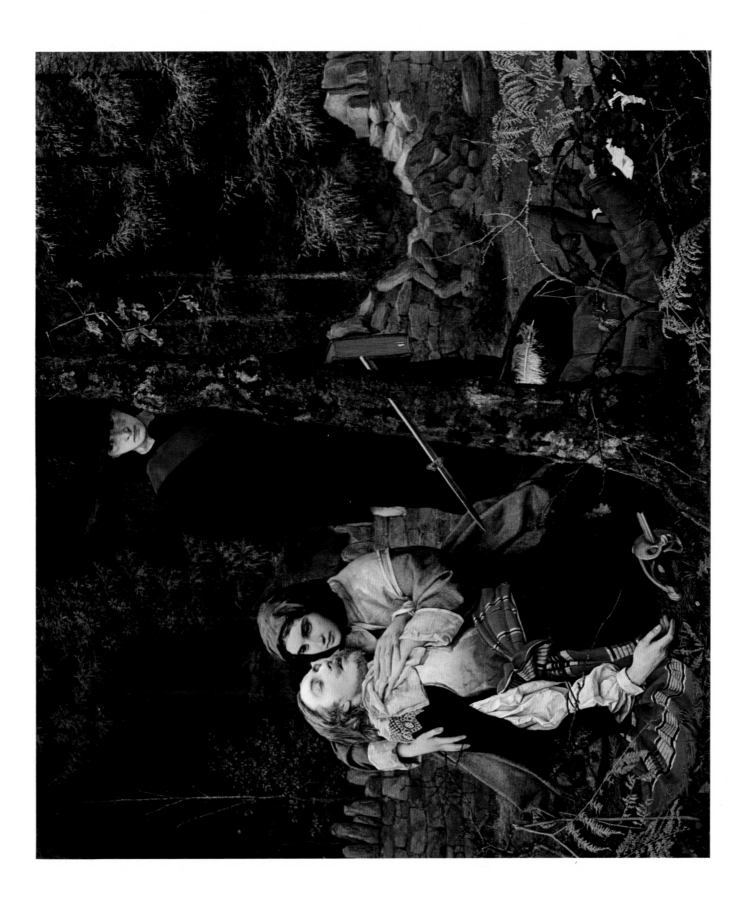

7) The Wounded Cavalier
30 x 41″
WILLIAM SHAKESPEARE BURTON
1824-1916

Guildhall, London
Photo—Cooper-Bridgeman Library

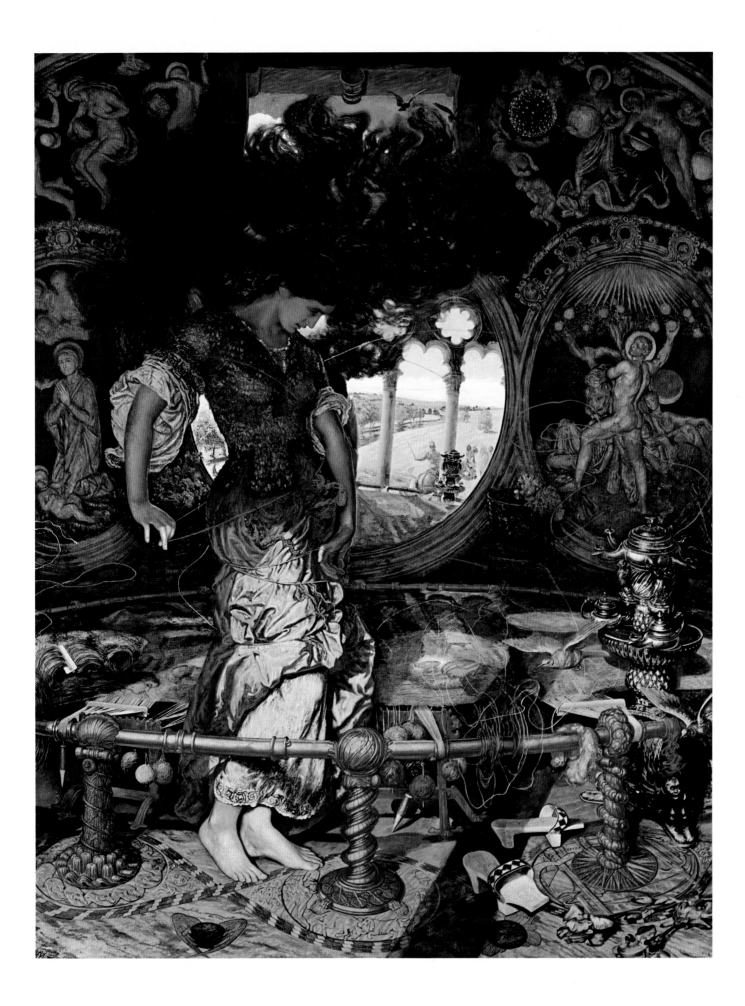

8) The Lady of Shalott
74 x 57″
WILLIAM HOLMAN HUNT
1827-1910
Wadsworth Atheneum, Hartford

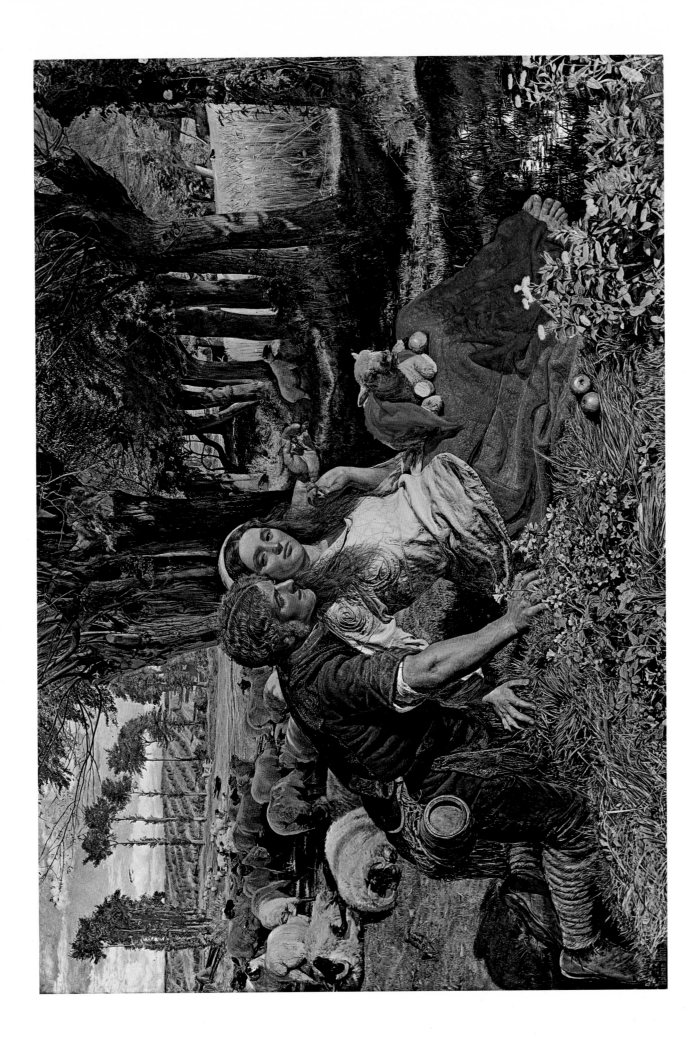

9) The Hireling Shepherd
1851 30½ x 43½"
WILLIAM HOLMAN HUNT
1827-1910
Manchester Art Gallery

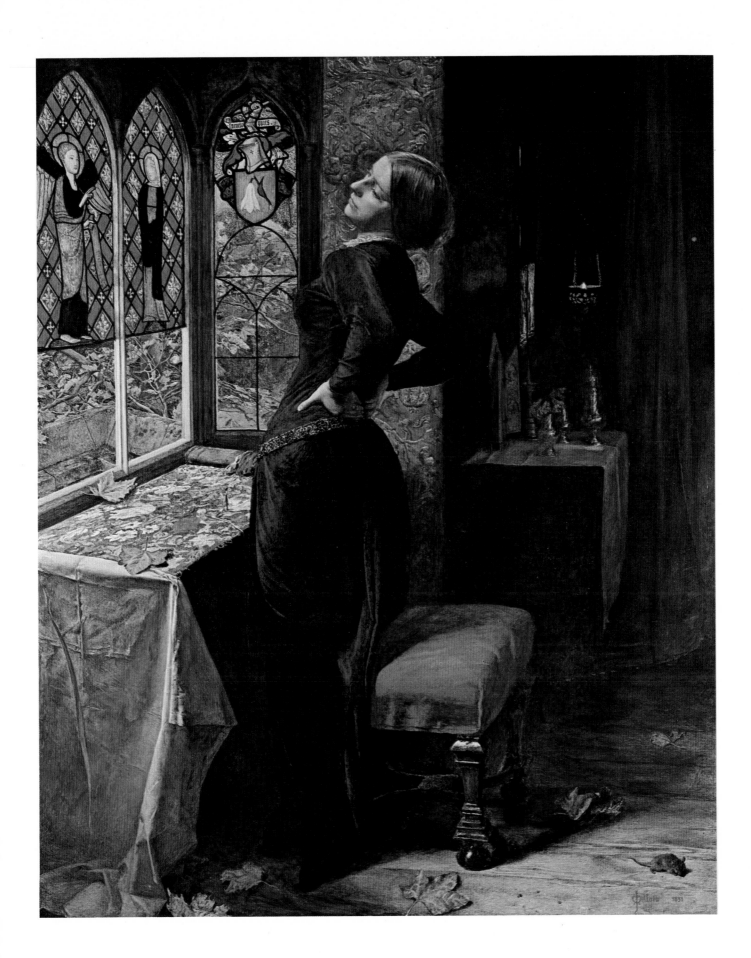

10) Mariana
1851 23$\frac{1}{4}$ x 19$\frac{1}{2}$″
JOHN EVERETT MILLAIS
1829-1896

The Makins Collection
Photo—Michael Holford

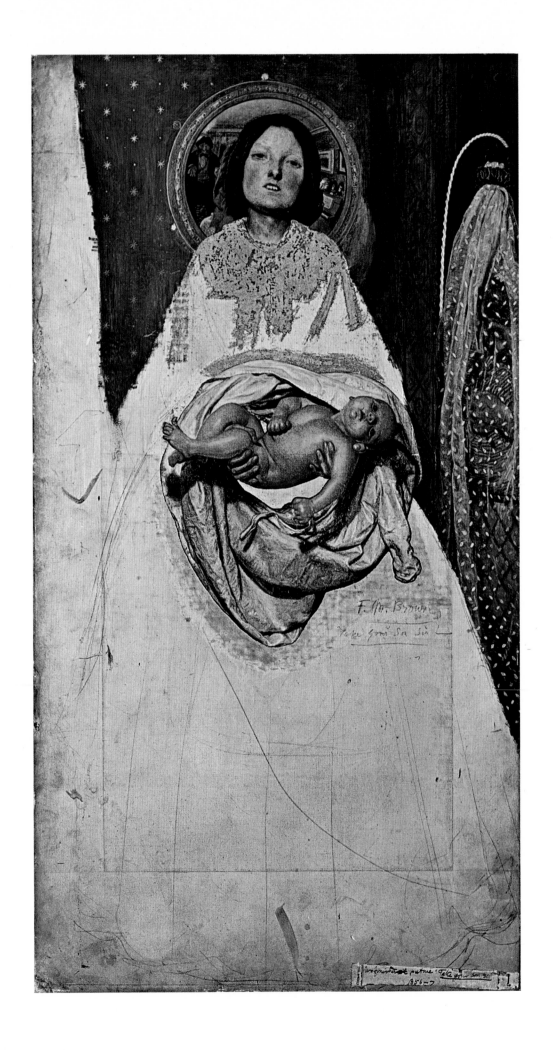

11) Take your son, Sir
1852-1892 (?) Unfinished
27$\frac{3}{4}$ x 15″
FORD MADOX BROWN
1821-1893

Tate Gallery, London
Photo—M. Slingsby

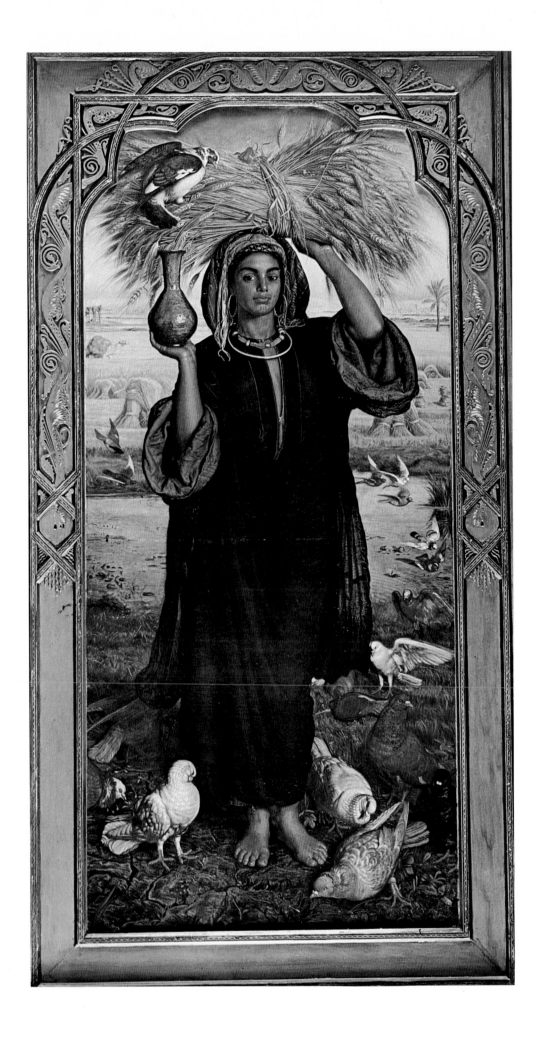

12) Afterglow in Egypt

1854-63 73 x 34″

WILLIAM HOLMAN HUNT

1827-1910

Southampton Art Gallery

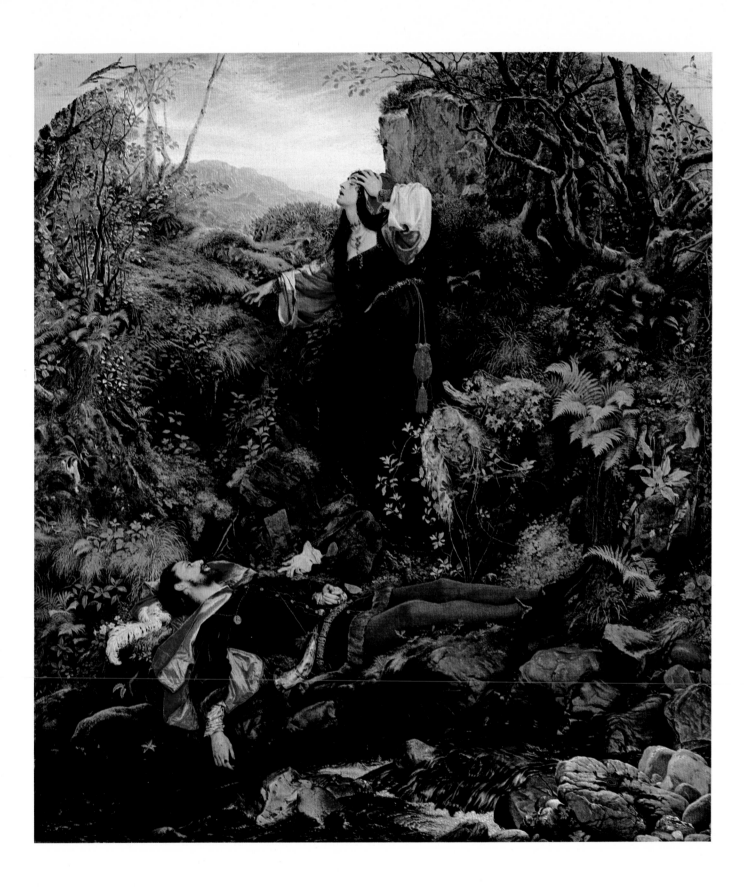

13) The Bluidie Tryste
1855 28¾ x 25⅝″
NOEL PATON
1821-1901
Glasgow Art Gallery

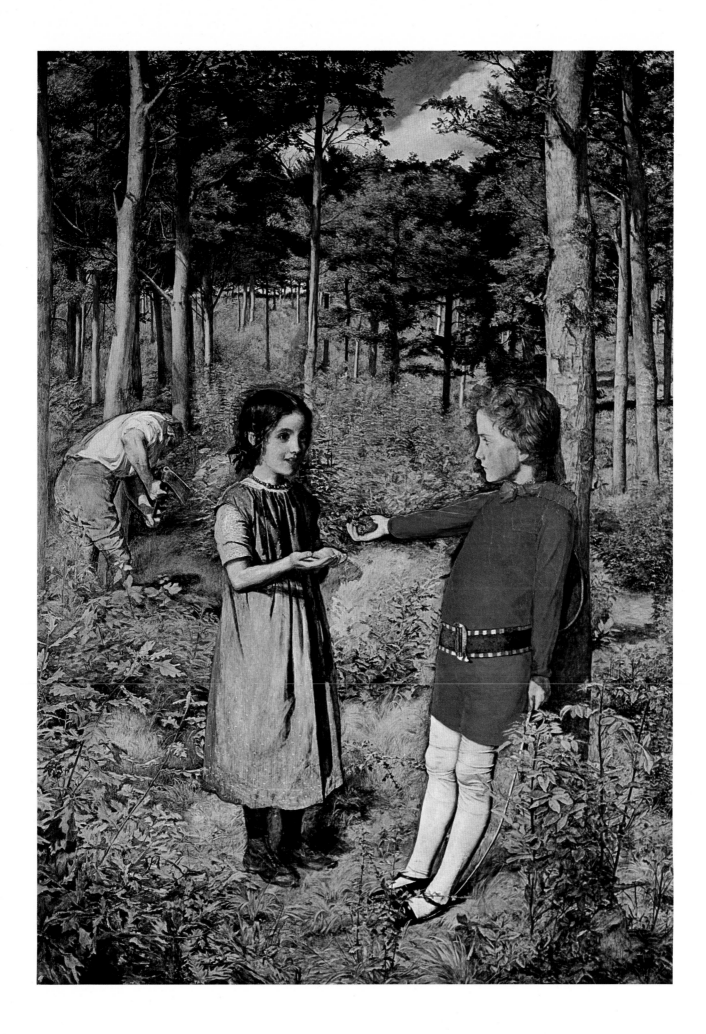

14) The Woodman's Daughter
JOHN EVERETT MILLAIS
1829-1896

Guildhall, London
Photo—Michael Holford

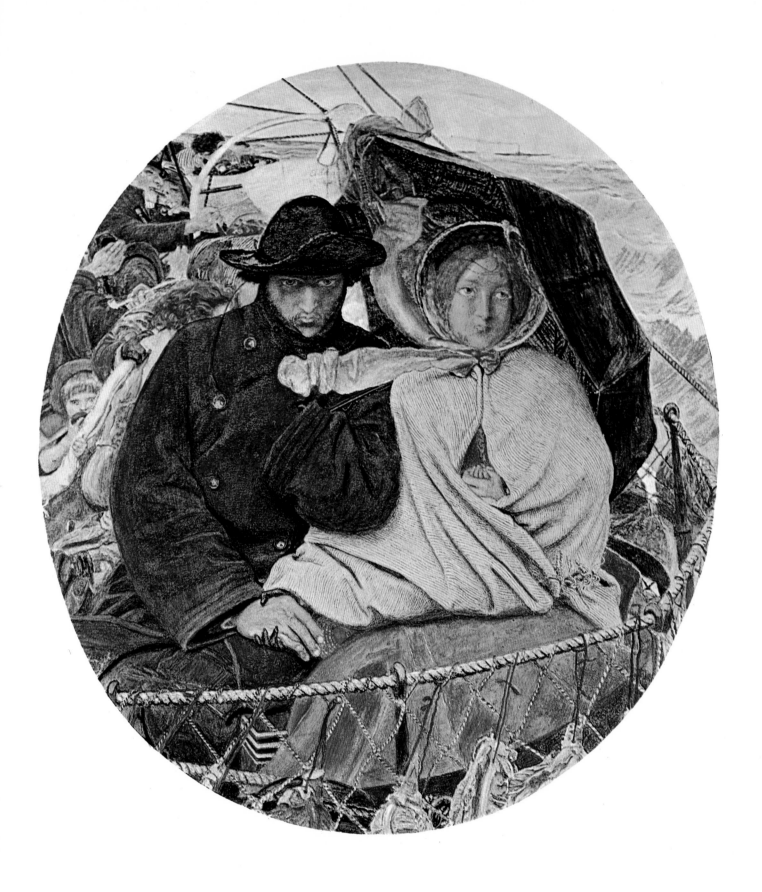

15) The Last of England
1855 32½ x 29½″
FORD MADOX BROWN
1821-1893
Birmingham Art Gallery

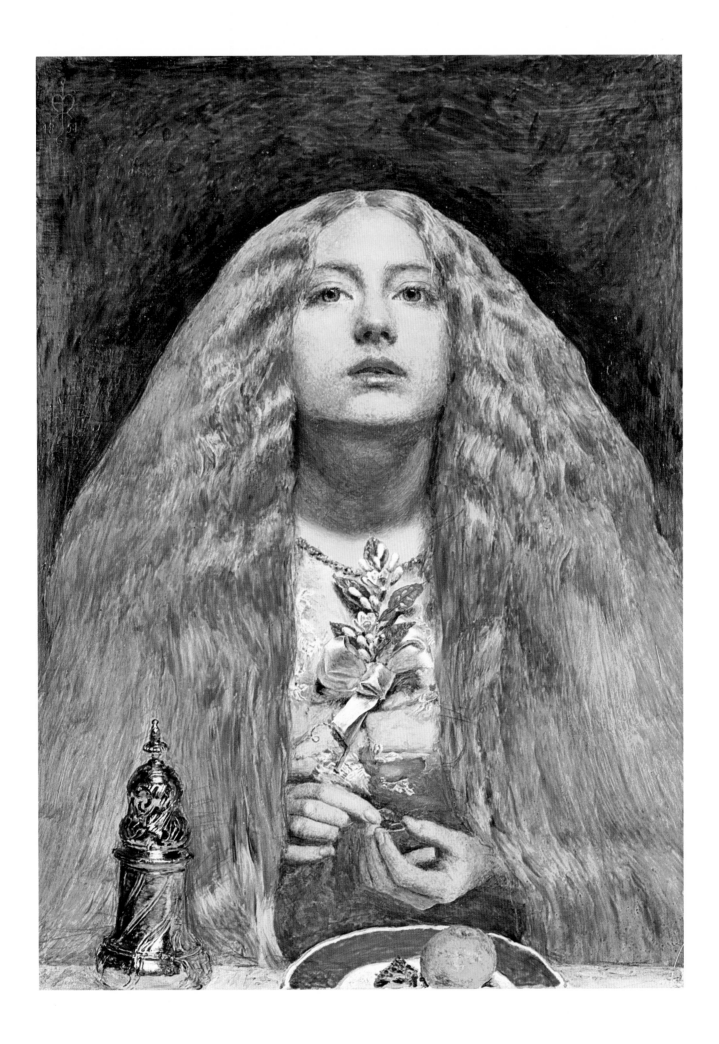

16) The Bridesmaid
JOHN EVERETT MILLAIS
1829-1896

Fitzwilliam Museum, Cambridge

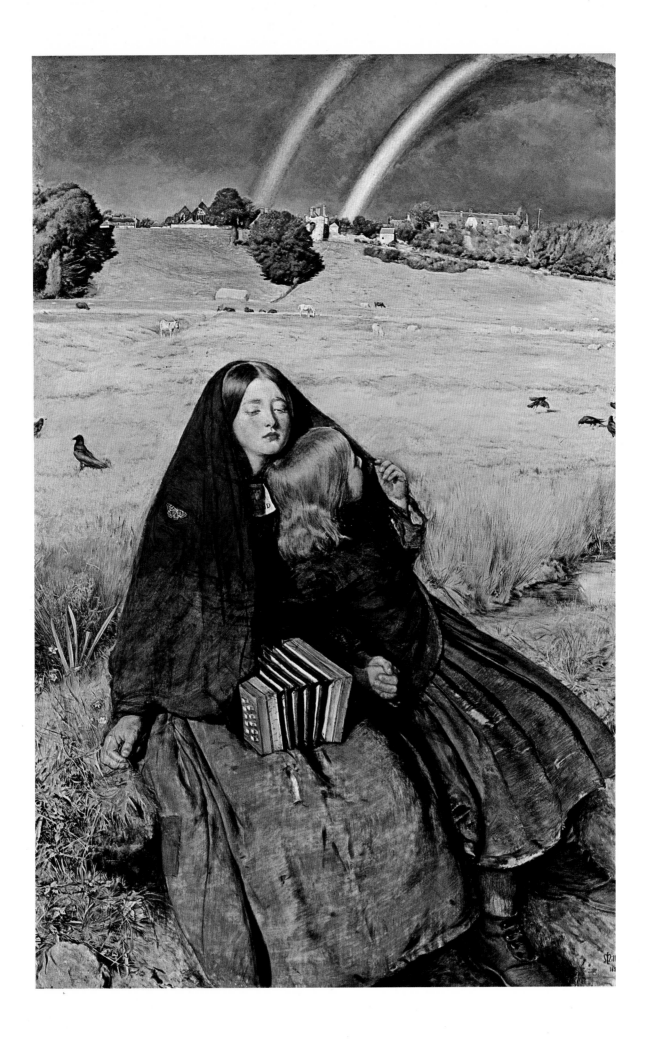

17) The Blind Girl
1856 32 x 24½″
JOHN EVERETT MILLAIS
1829-1896
Birmingham Art Gallery

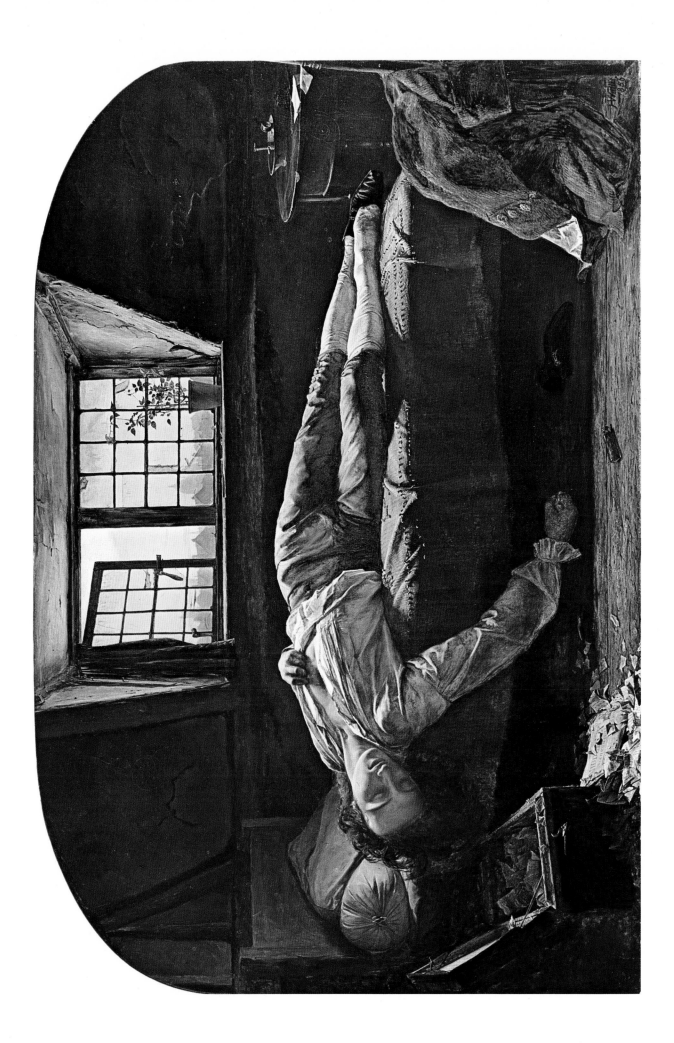

18) Chatterton

c.1856 24½ x 36¾"

HENRY WALLIS

1830-1916

Tate Gallery, London

Photo—M. Slingsby

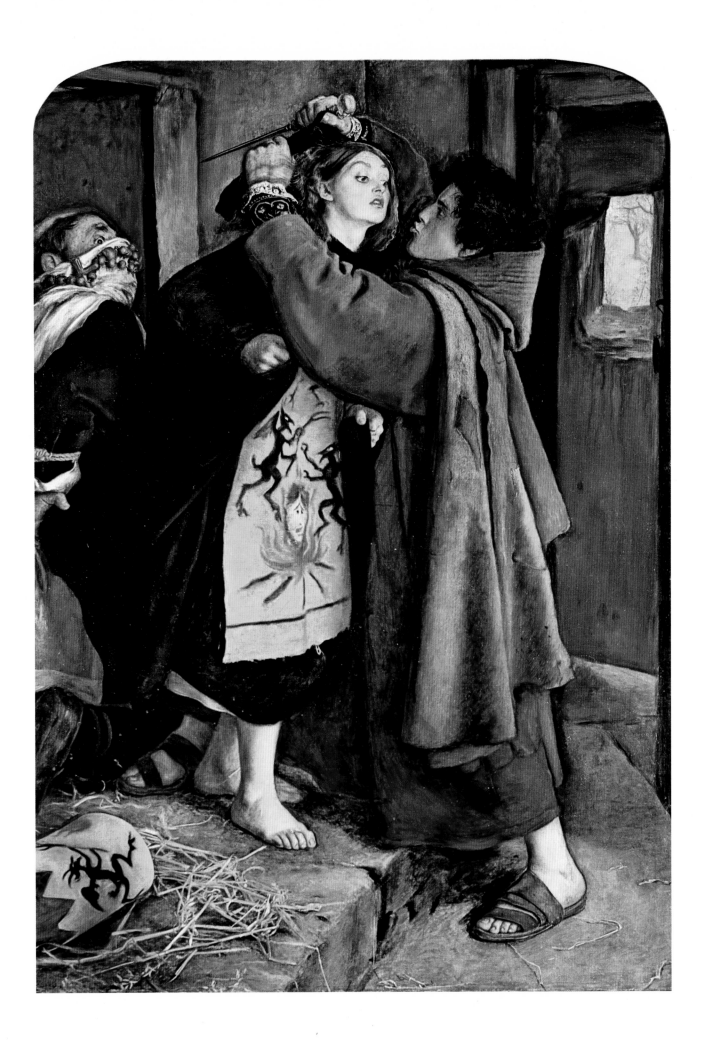

19) The Escape of a Heretic
1857 42½ x 30½″
JOHN EVERETT MILLAIS
1829-1896

Ponce Museum, Puerto Rico

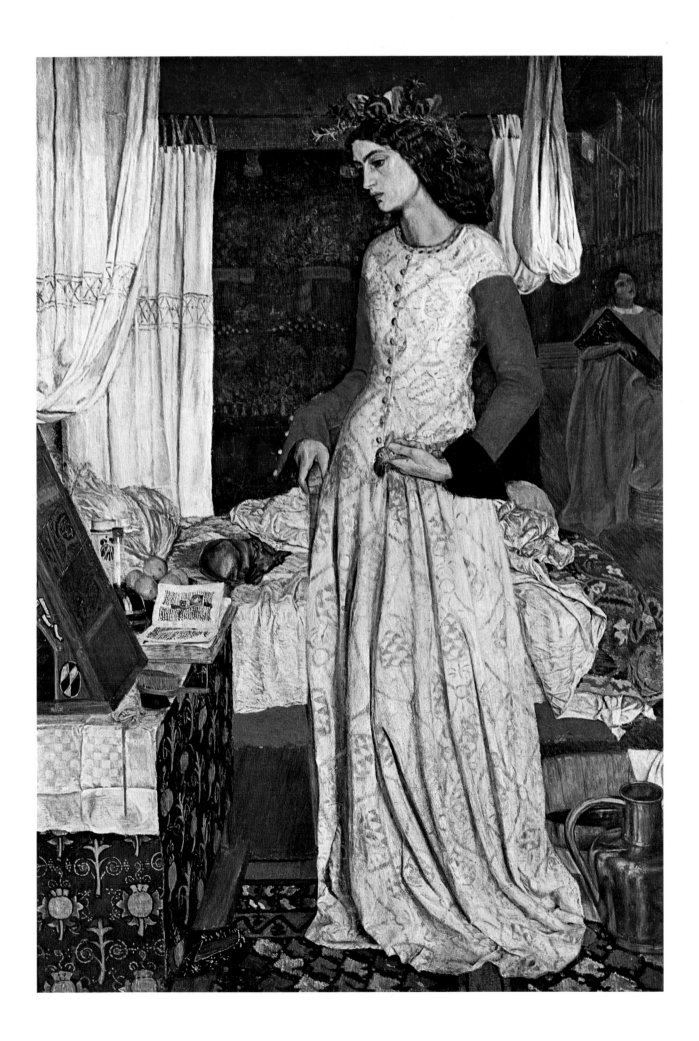

20) Queen Guinevere
1858 28¼ x 19¾"
WILLIAM MORRIS
1834-1896

Tate Gallery, London
Photo—M. Slingsby

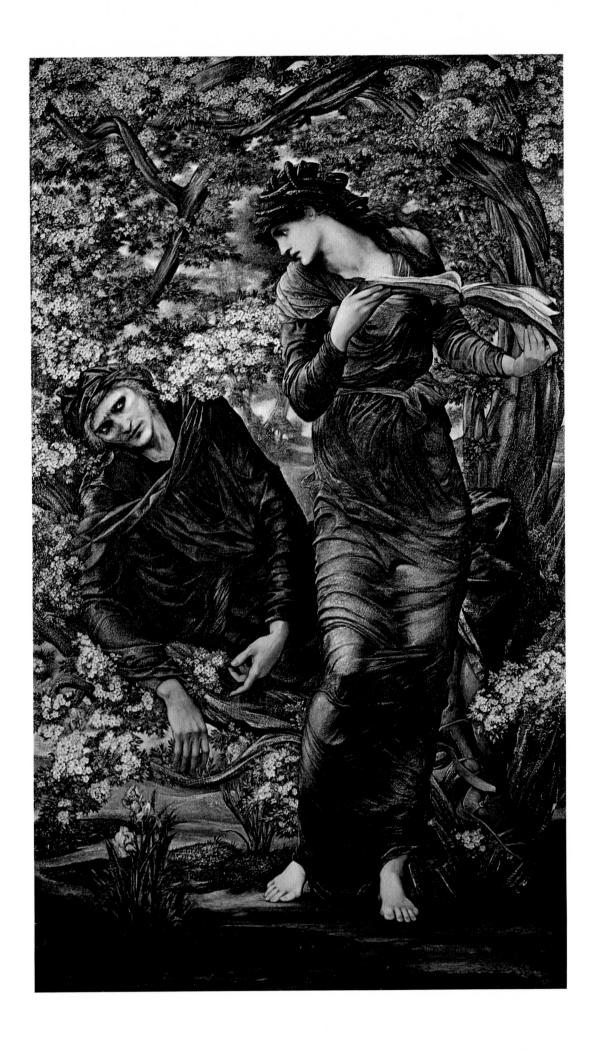

21) The Beguiling of Merlin
EDWARD BURNE-JONES
1833-1898
Lady Lever Art Gallery, Port Sunlight

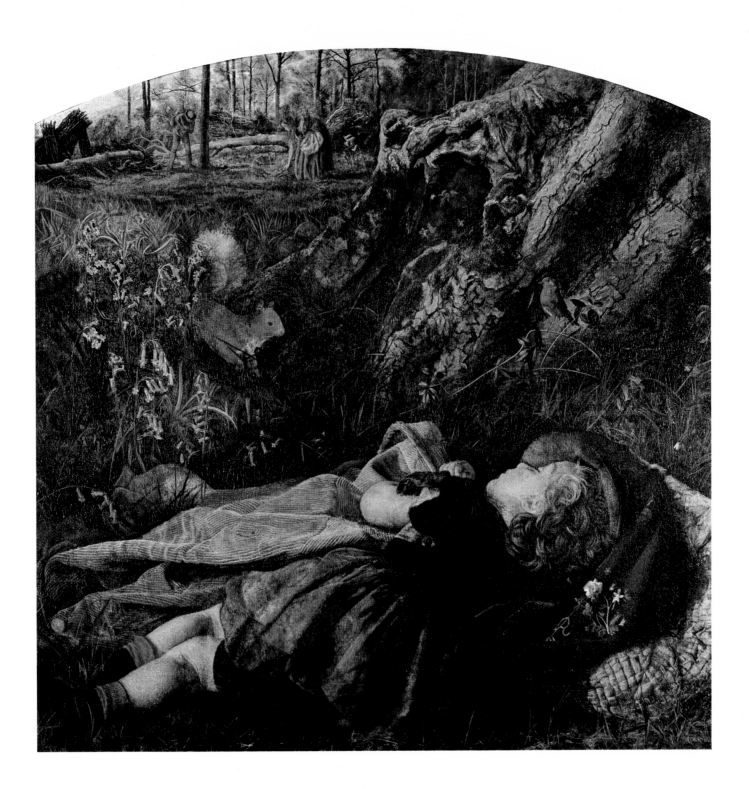

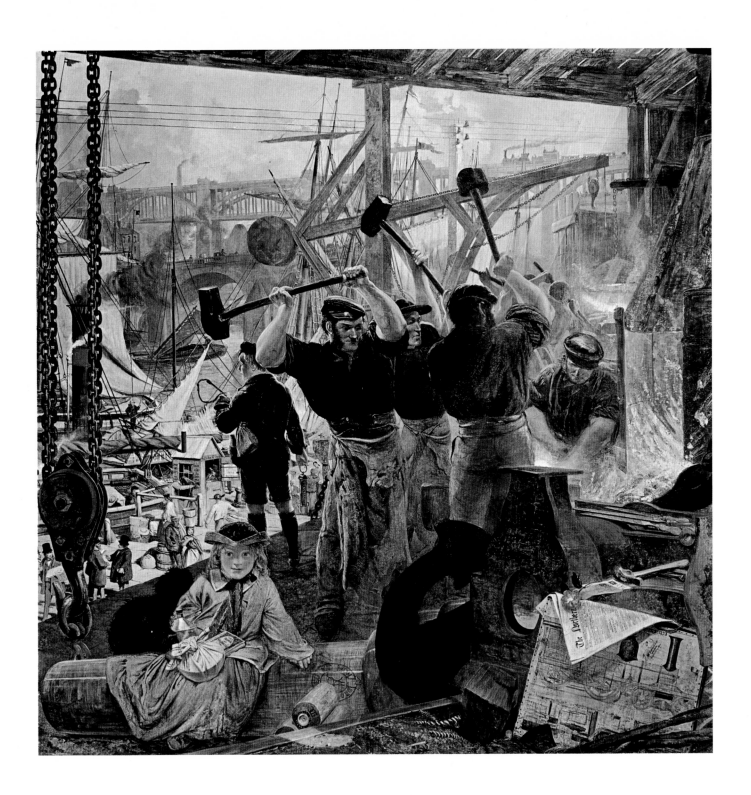

23) Newcastle Quayside in 1861
WILLIAM BELL SCOTT
1811-1890

National Trust, Cambo, Northumberland
Photo-Philipson

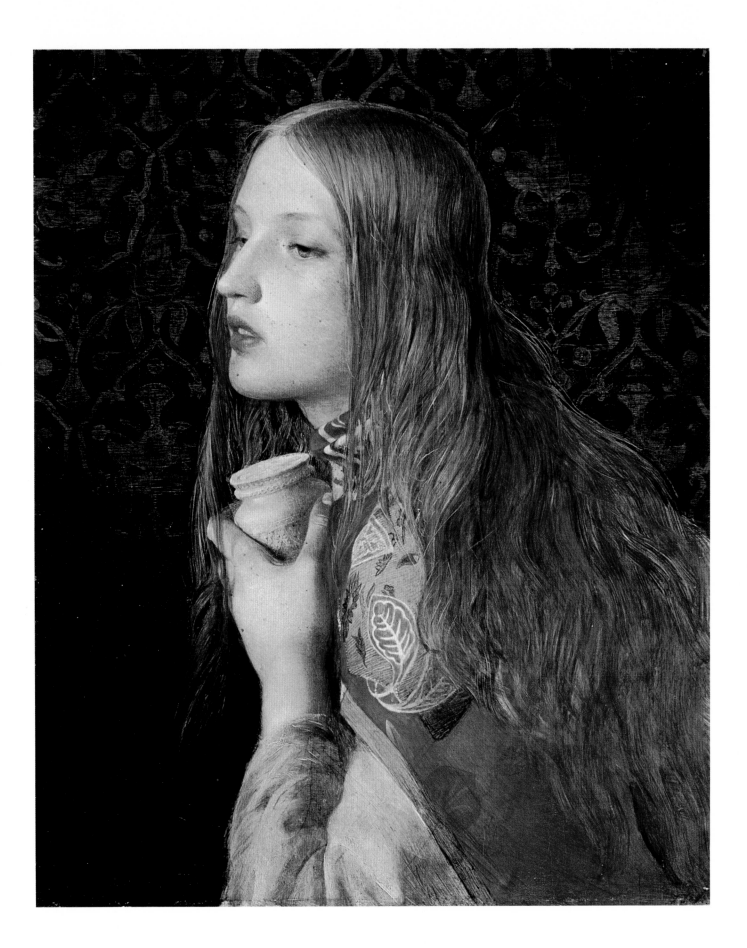

24) Mary Magdalene
1862 13 x 10½″
FREDERICK SANDYS
1832-1904

Delaware Art Museum, Wilmington, Del.

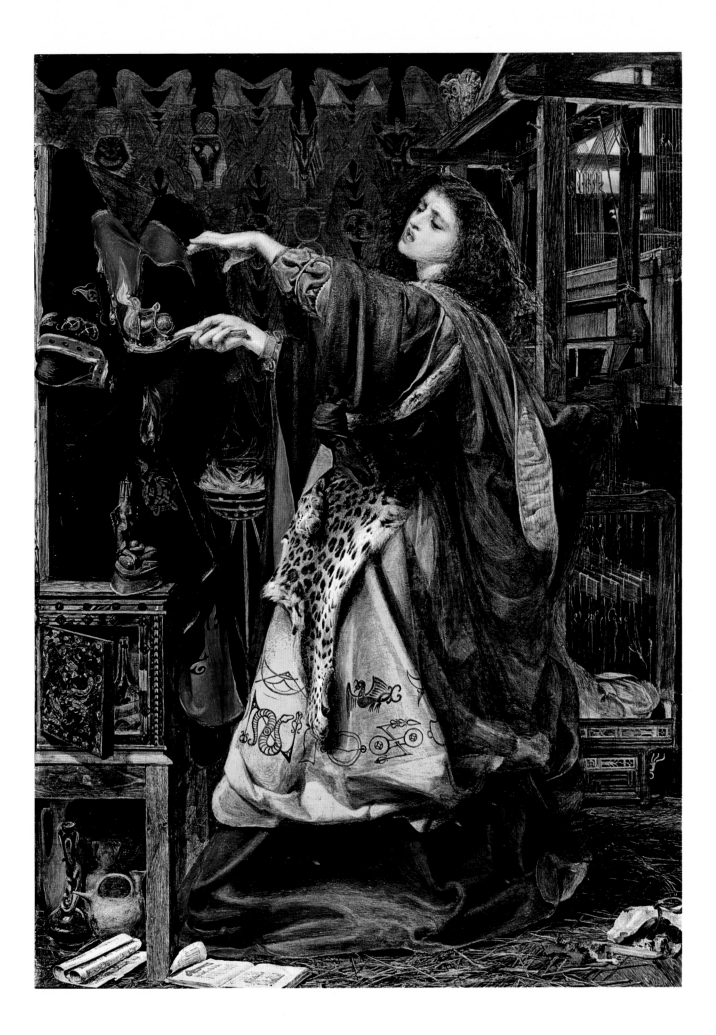

25) Morgan le Fay
1864 24¾ x 17½″
FREDERICK SANDYS
1832-1904

Birmingham Art Gallery
Photo—Cecil Reilly

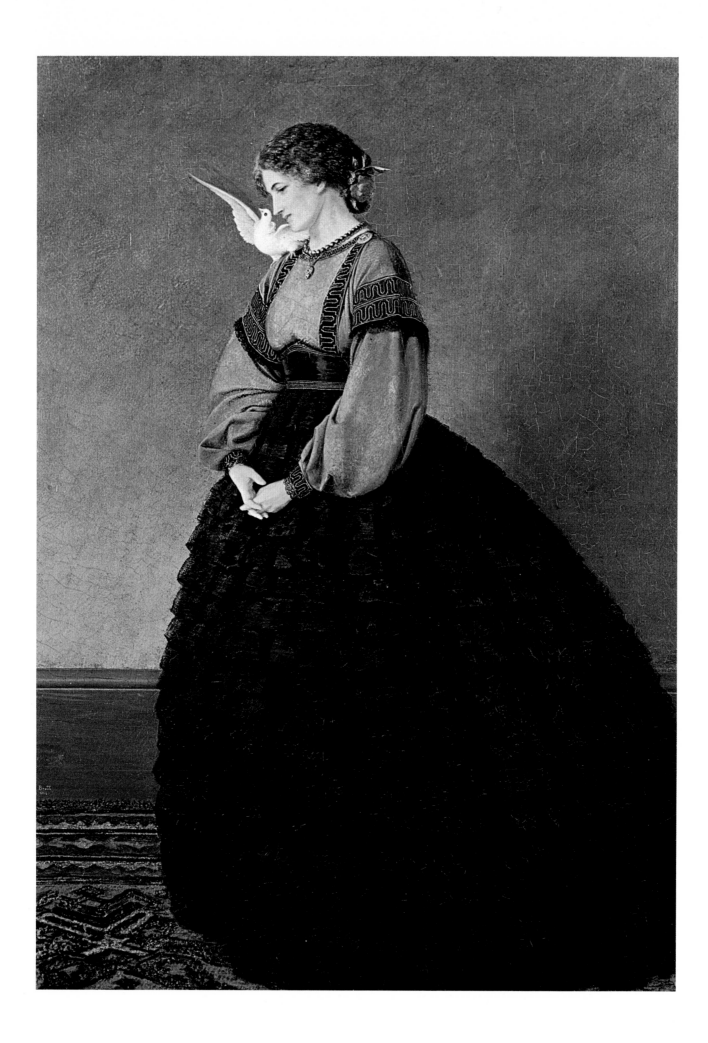

26) Lady with a Dove
1864 24 x 18″
JOHN BRETT
1830-1902

Tate Gallery, London
Photo—M. Slingsby

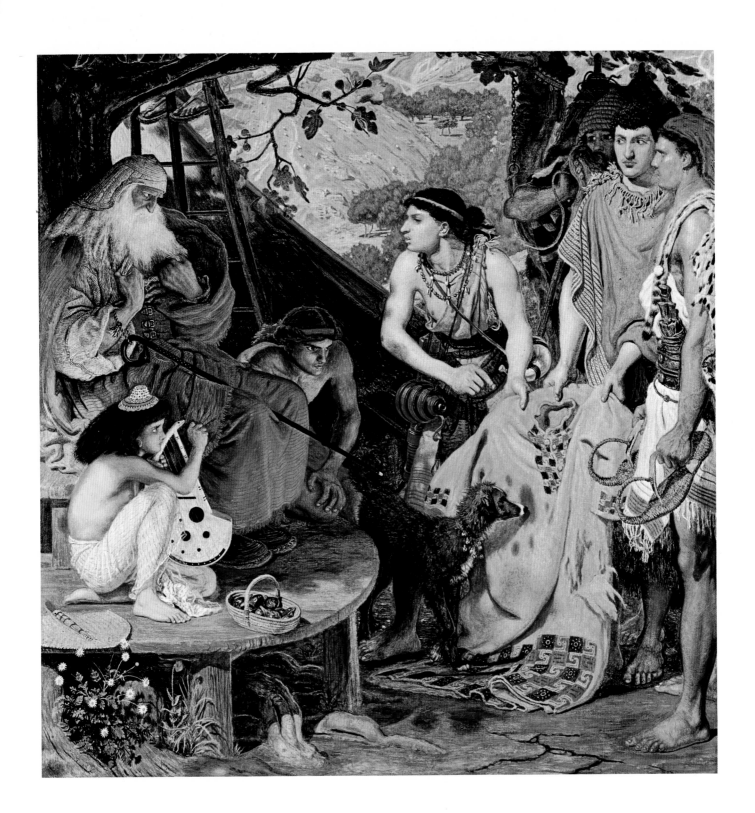

27) The Coat of Many Colors
1866 $42\frac{1}{2}$ x $40\frac{5}{8}''$
FORD MADOX BROWN
1821-1893
Walker Art Gallery, Liverpool

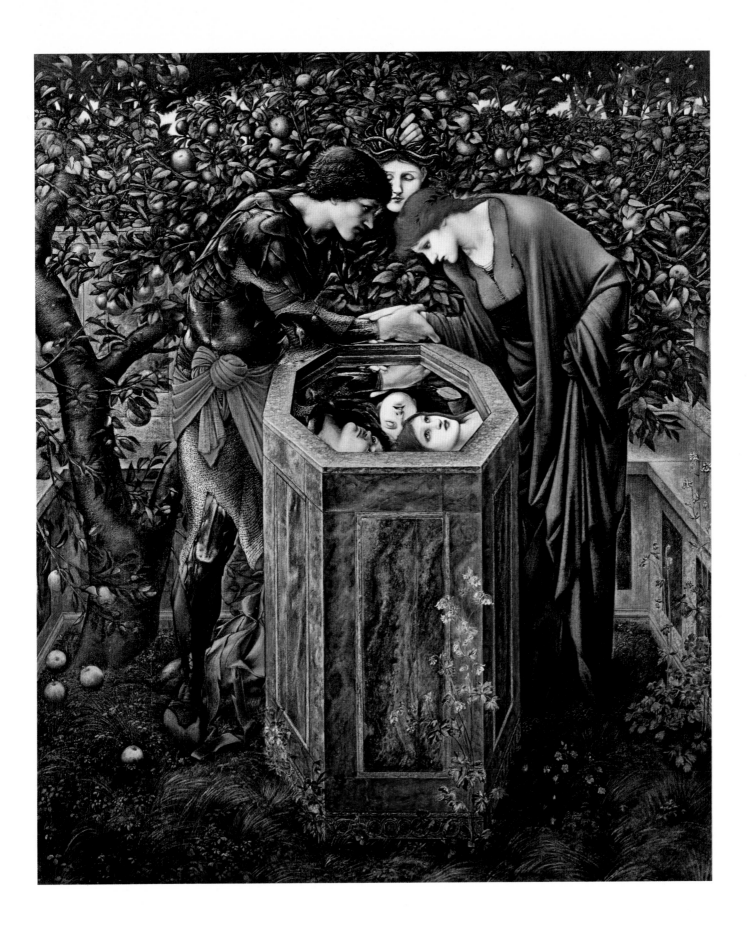

28) The Baleful Head
62 x 52"
EDWARD BURNE-JONES
1833-1898
Stuttgart Staatsgalerie

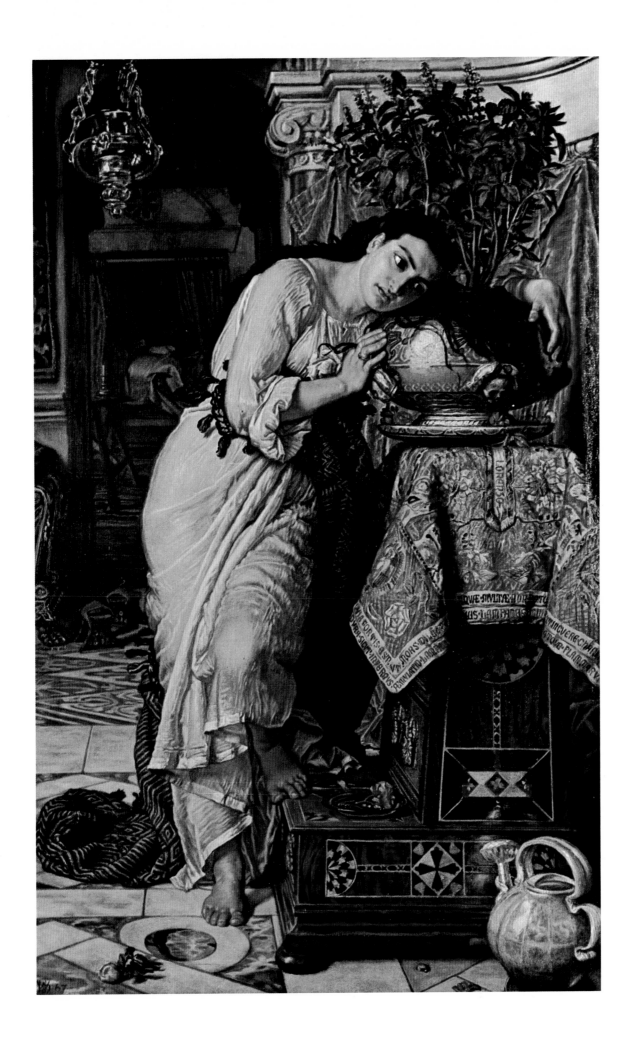

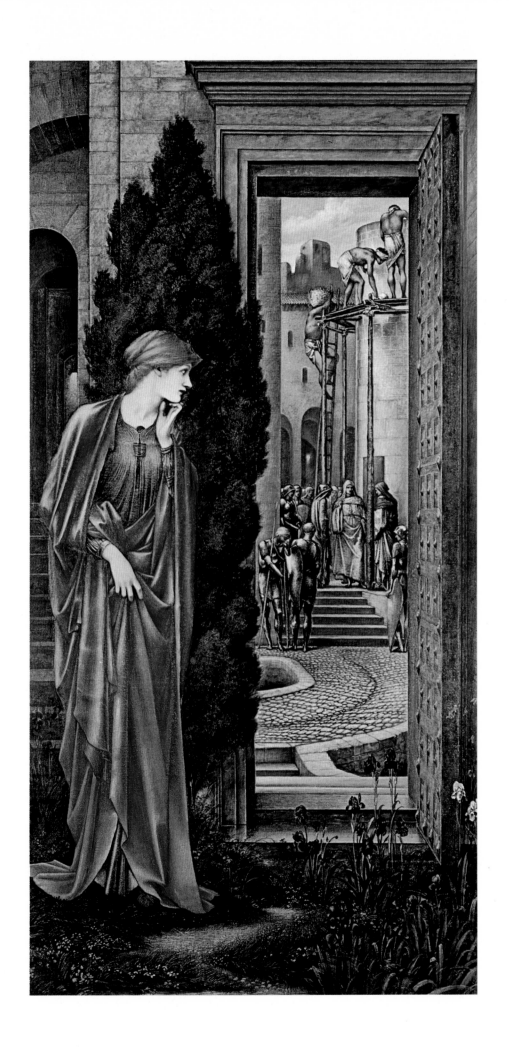

30) Danae or the Tower of Brass
EDWARD BURNE-JONES
1833-1898
Glasgow Art Gallery

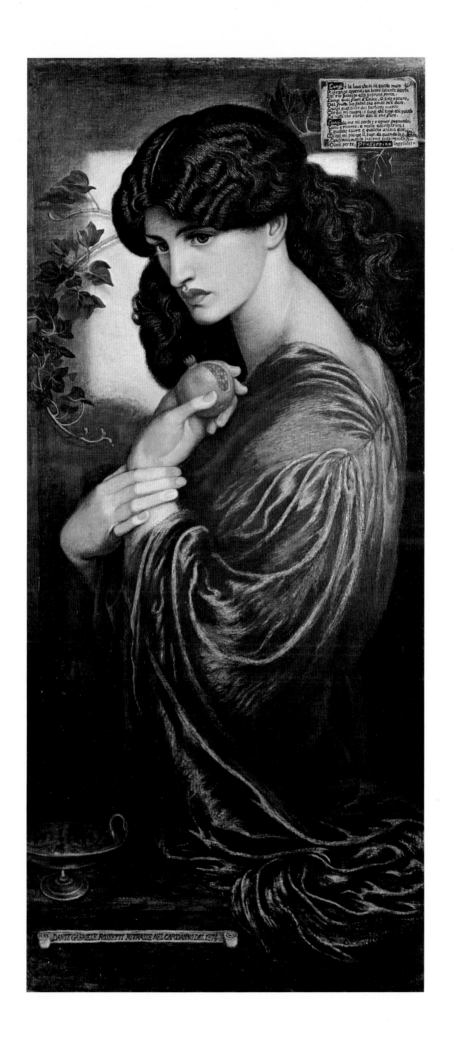

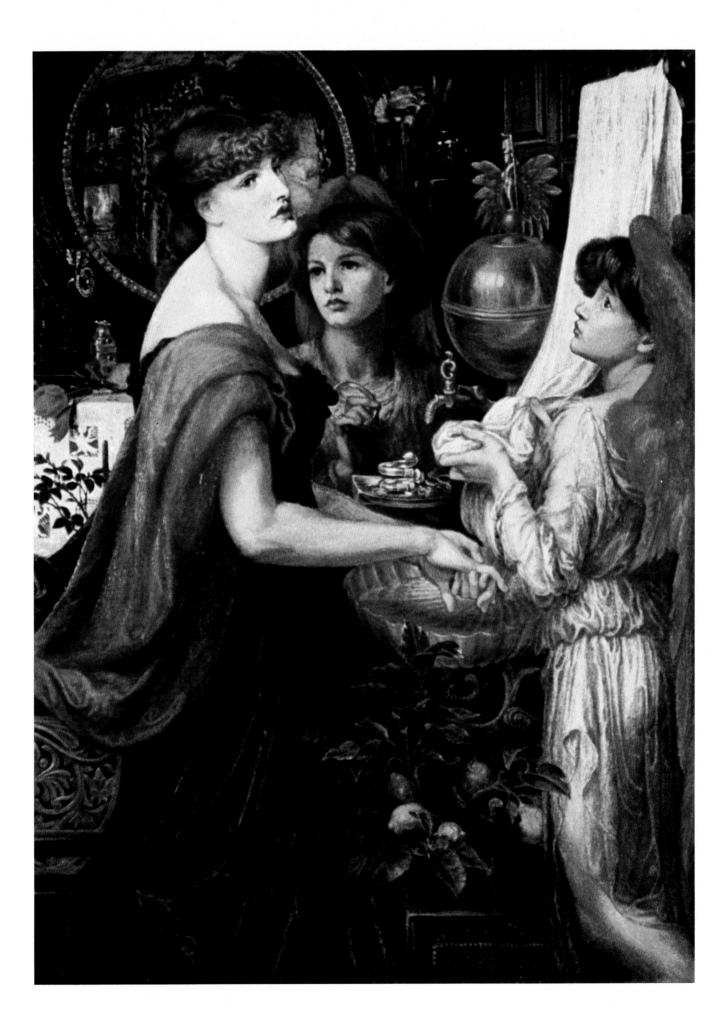

32) La Bella Mano
1875 62 x 46″
DANTE GABRIEL ROSSETTI
1828-1882

Delaware Art Museum, Wilmington, Del.

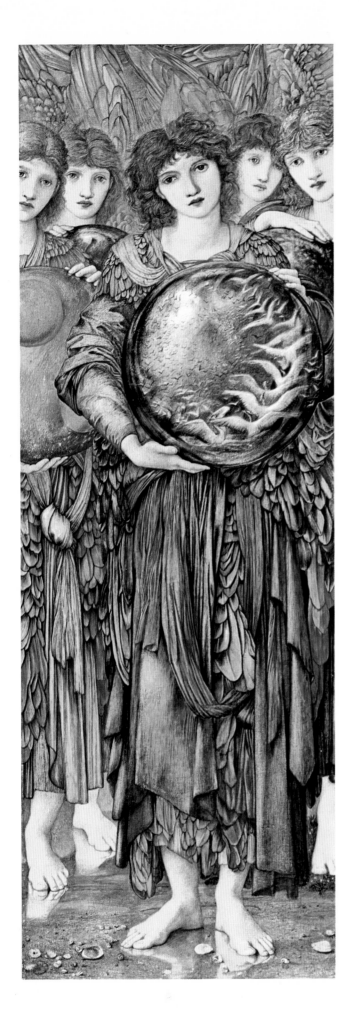
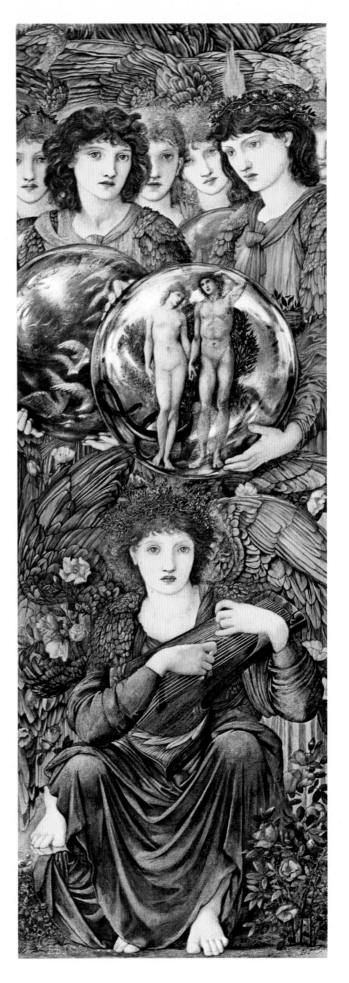

33) The Angels of Creation—Days five and six

1875-76 47½ x 14¼"

EDWARD BURNE-JONES

1833-1898

Fogg Art Museum, Harvard University

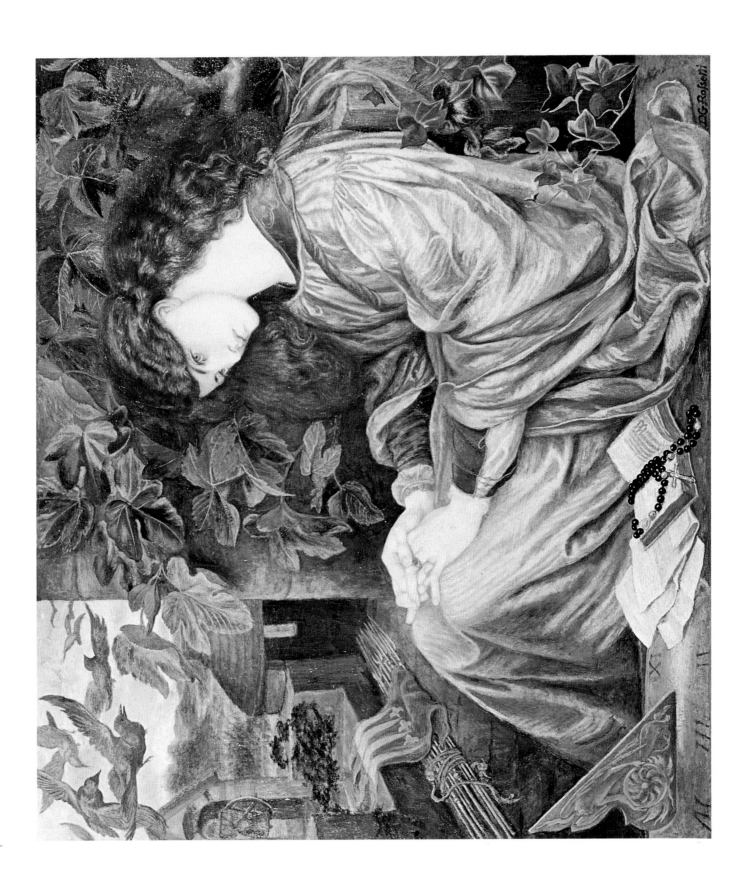

34) La Pia de'Tolomei
1881 41½ x 47½"
DANTE GABRIEL ROSSETTI
1828-1882
University of Kansas Museum, Lawrence

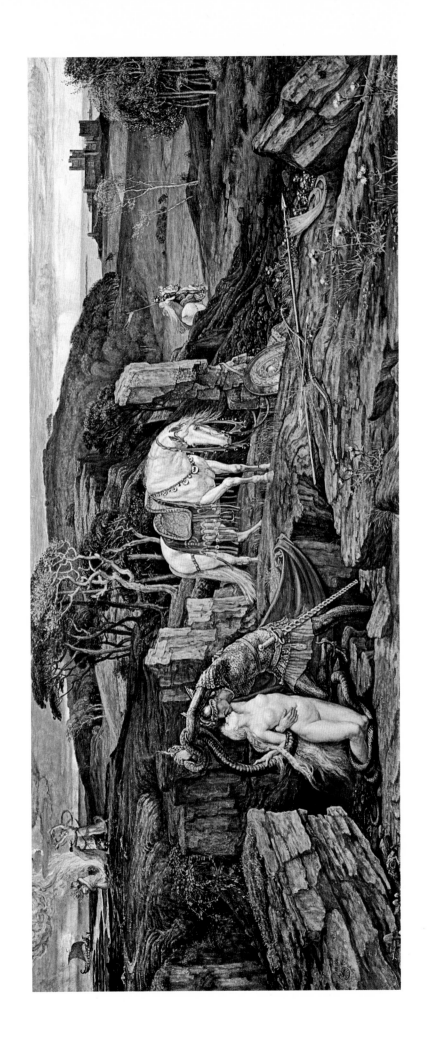

35) The Laidly Worm

1881 29¾ x 57¾″

WALTER CRANE

1845-1915

Galleria del Levante, Munich

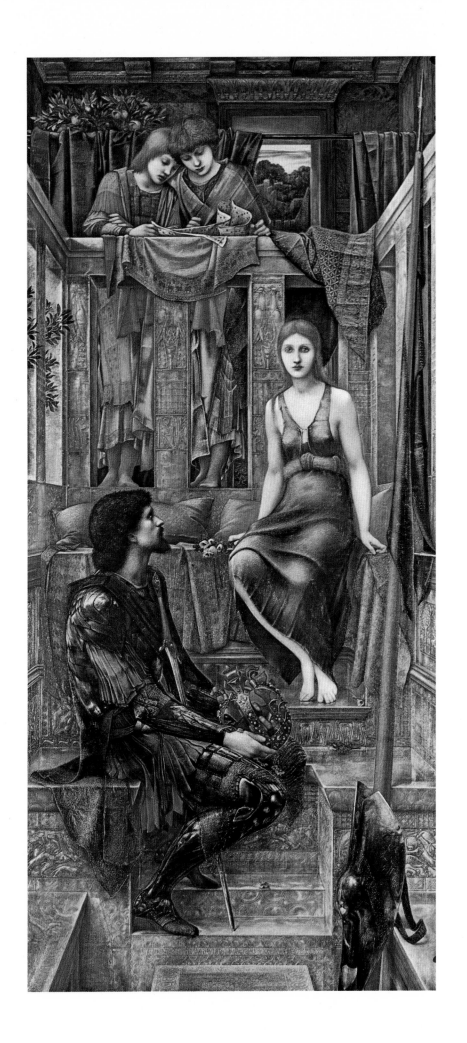

36) King Cophetua and the Beggar Maid
1884 115½ x 53½"
EDWARD BURNE-JONES
1833-1898

Tate Gallery, London
Photo—M. Slingsby

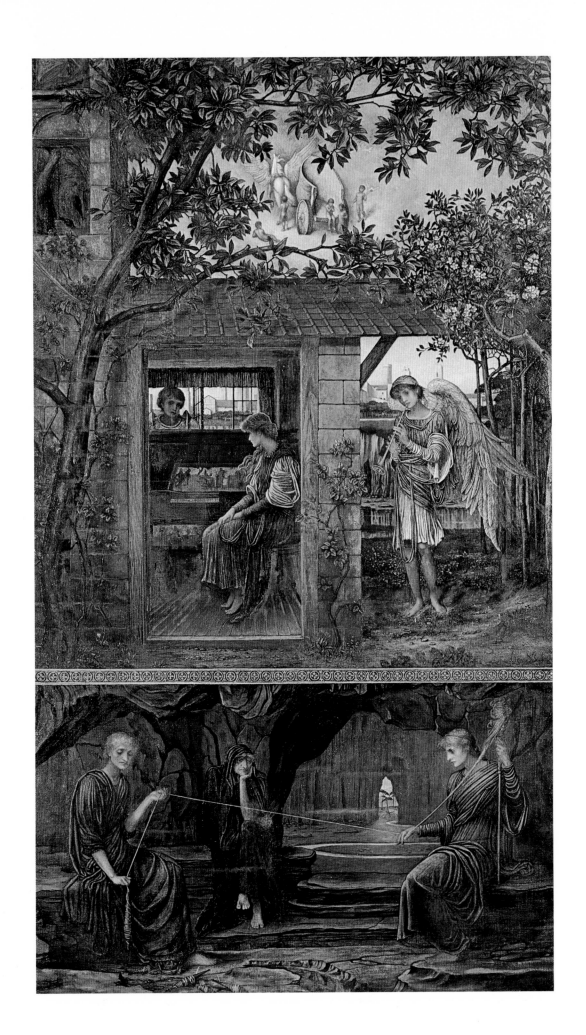

37) A Golden Thread
c.1885 28½ x 16¾"
JOHN MELHUISH STRUDWICK
1849-1935

Tate Gallery, London
Photo—M. Slingsby

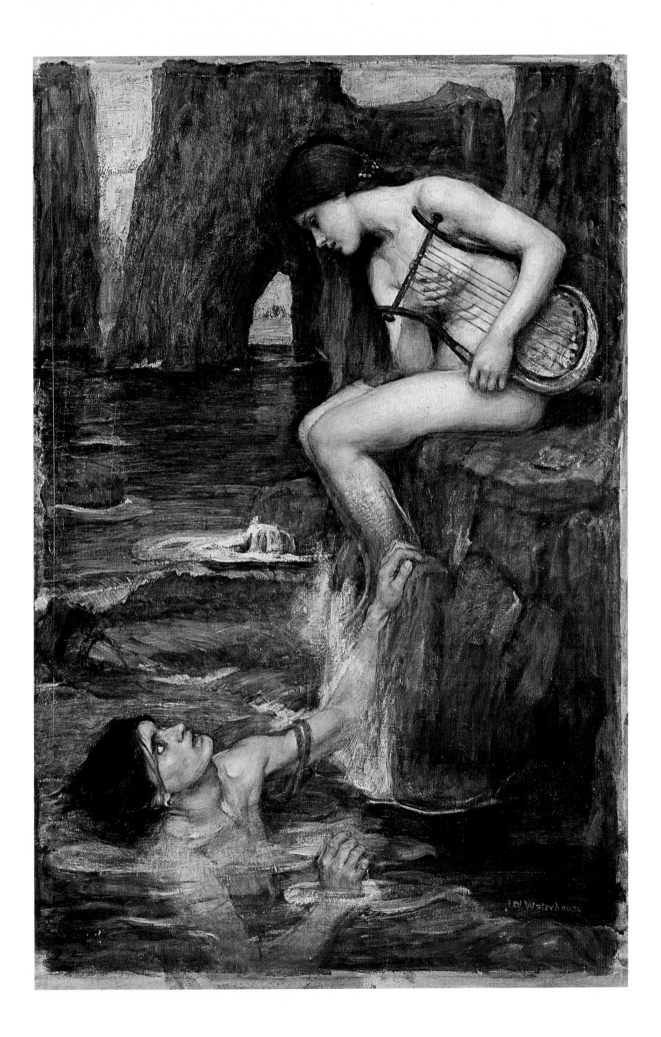

38) Sirene

33⅓ x 22¼″

JOHN WILLIAM WATERHOUSE

1849-1917

Galleria del Levante, Munich

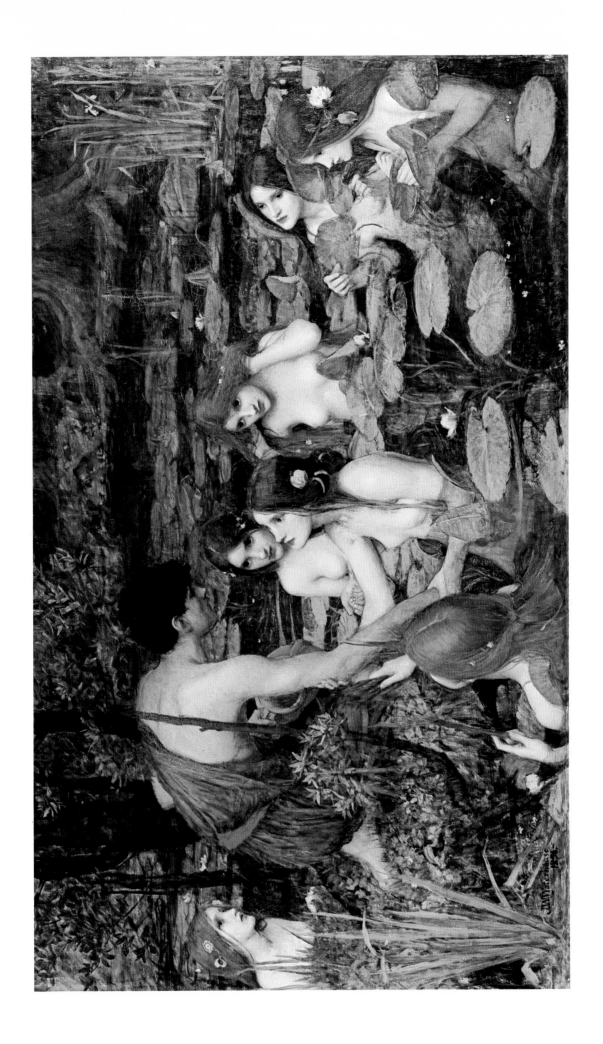

39) Hylas and the Nymphs

JOHN WILLIAM WATERHOUSE

1849-1917

Manchester Art Gallery

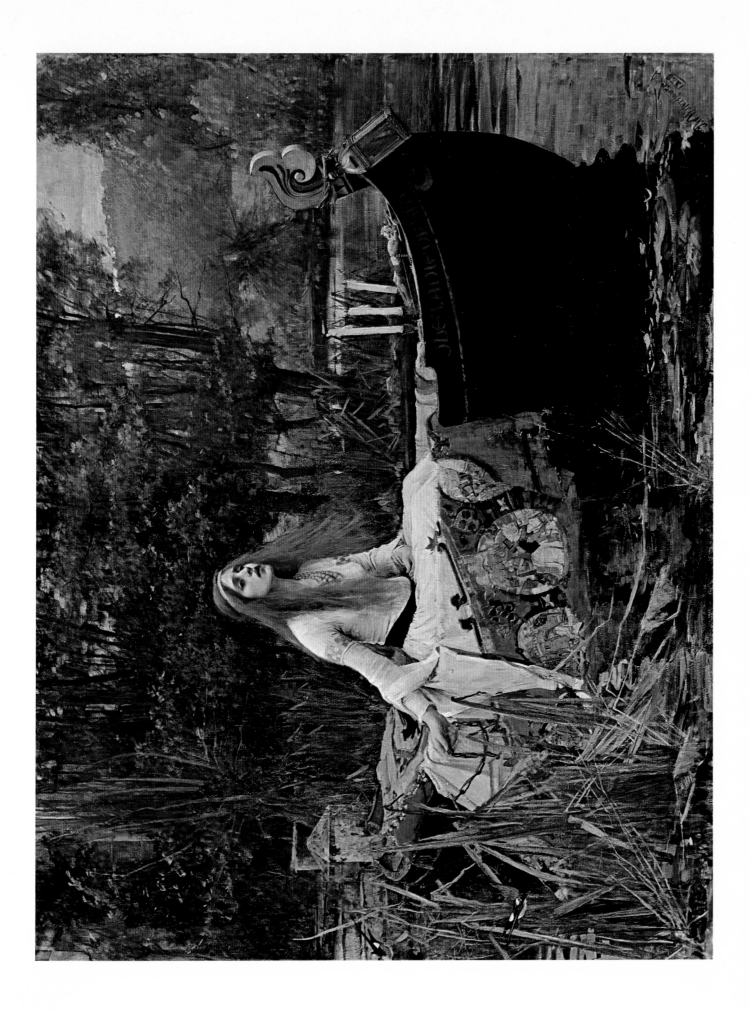

40) The Lady of Shalott
1888 60¼ x 78¾"
JOHN WILLIAM WATERHOUSE
1849-1917

Tate Gallery, London
Photo—M. Slingsby